Patterning Techniques

A pattern is a repetition of shapes and lines that can be simple or complex depending on your preference and the space you want to fill. Even complicated patterns start out very simple with either a line or a shape.

Repeating shapes (floating)

Shapes and lines are the basic building blocks of patterns. Here are some example shapes that we can easily turn into patterns:

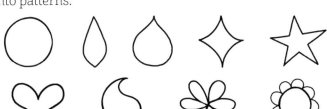

Before we turn these shapes into patterns, let's spruce them up a bit by outlining, double-stroking (going over a line more than once to make it thicker), and adding shapes to the inside and outside.

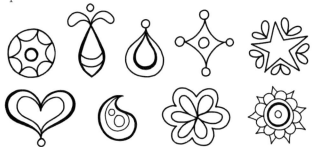

To create a pattern from these embellished shapes, all you have to do is repeat them, as shown below. You can also add small shapes in between the embellished shapes, as shown.

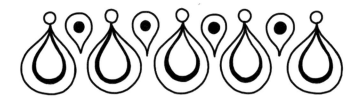

These are called "floating" patterns because they are not attached to a line (like the ones described in the next example). These floating patterns can be used to fill space anywhere and can be made big or small, short or long, to suit your needs.

Tip

Draw your patterns in pencil first, and then go over them with black or color. Or draw them with black ink and color them afterward. Or draw them in color right from the start. Experiment with all three ways and see which works best for you!

Tip

If you add shapes and patterns to these coloring pages using pens or markers, make sure the ink is completely dry before you color on top of them; otherwise, the ink may smear.

Repeating shapes (attached to a line)

Start with a line, and then draw simple repeating shapes along the line. Next, embellish each shape by outlining, double-stroking, and adding shapes to the inside and outside. Check out the example below.

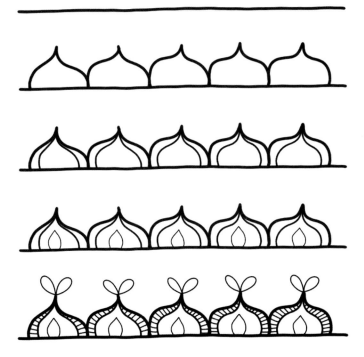

You can also draw shapes in between a pair of lines, like this:

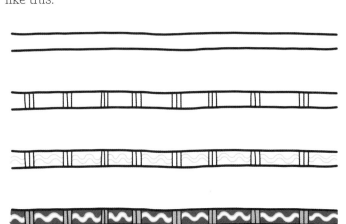

Embellishing a decorative line

You can also create patterns by starting off with a simple decorative line, such as a loopy line or a wavy line, and then adding more details. Here are some examples of decorative lines:

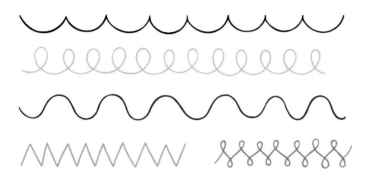

Color repetition

Patterns can also be made by repeating sets of colors. Create dynamic effects by alternating the colors of the shapes in a pattern so that the colors themselves form a pattern.

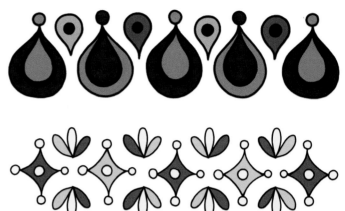

Next, embellish the line by outlining, double-stroking, and adding shapes above and below the line as shown here:

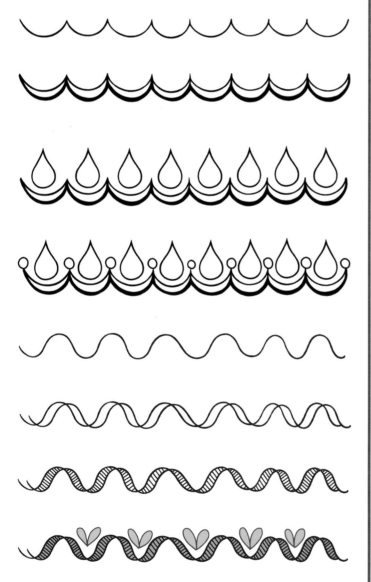

Tip

Patterns don't have to follow a straight line—they can curve, zigzag, loop, or go in any direction you want! You can draw patterns on curved lines, with the shapes following the flow of the line above or below.

These types of patterns look great when attached to the inner or outer edge of a drawing, such as the inside of a flower petal or butterfly wing.

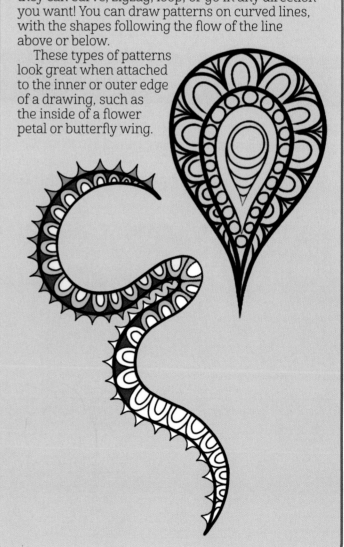

Coloring Techniques & Media

My favorite way to color is to combine a variety of media so I can benefit from the best that each has to offer. When experimenting with new combinations of media, I strongly recommend testing first by layering the colors and media on scrap paper to find out what works and what doesn't. It's a good idea to do all your testing in a sketchbook and label the colors/brands you used for future reference.

Markers & colored pencils

Smooth out areas colored with marker by going over them with colored pencils. Start by coloring lightly, and then apply more pressure if needed.

 + =

marker colored pencil smoother result

Test your colors on scrap paper first to make sure they match. You don't have to match the colors if you don't want to, though. See the cool effects you can achieve by layering a different color on top of the marker below.

Markers (horizontal) overlapped with colored pencils (vertical).

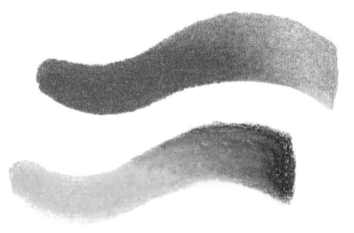

Purple marker overlapped with white and light blue colored pencils. Yellow marker overlapped with orange and red colored pencils.

Markers & gel pens

Markers and gel pens go hand in hand, because markers can fill large spaces quickly, while gel pens have fine points for adding fun details.

 White gel pens are especially fun for drawing over dark colors, while glittery gel pens are great for adding sparkly accents.

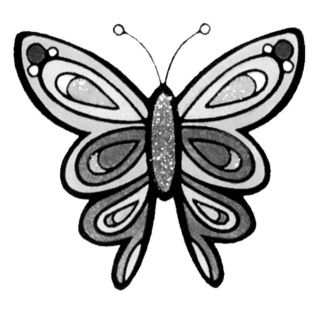

This butterfly was mostly colored with marker, but glittery gel pens were used to add sparkly accents.

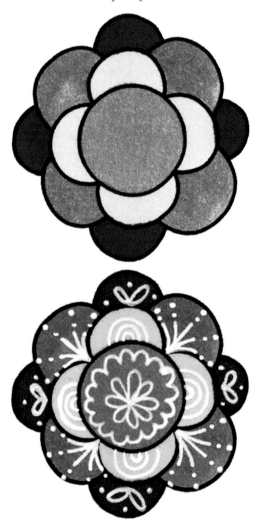

The top flower above was colored with markers, while the bottom flower has details added over top of the marker with white gel pen.

Shading

Shading is a great way to add depth and sophistication to a drawing. Even layering just one color on top of another color can be enough to indicate shading. And of course, you can combine different media to create shading.

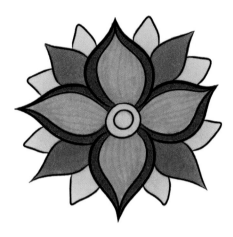

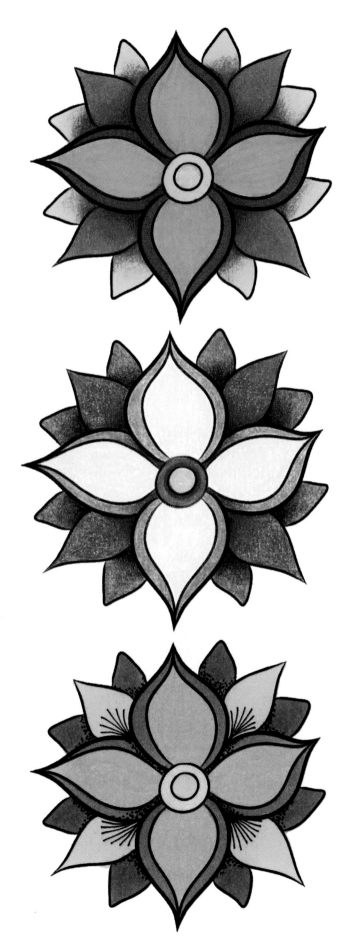

The flower on the left was colored with markers. In the flower on the right, the inner corners of each petal were shaded with colored pencil to create a sense of overlapping.

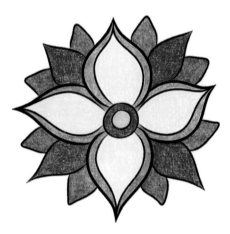

The flower on the left was colored with colored pencils. In the flower on the right, shading has been added with colored pencils.

Lines and dots were added to the flower on the left with black ink to indicate shading. In the flower on the right, color has been added over the black ink with markers.

Color Theory

One of the most common questions beginners ask when they're getting ready to color is, "What colors should I use?" The fun thing about coloring is that there is no such thing as right or wrong. You can use whatever colors you want, wherever you want! Coloring offers a lot of freedom, allowing you to explore a whole world of possibilities.

With that said, if you're looking for a little guidance, it is helpful to understand some basic color theory. Let's look at the nifty color wheel in the shape of a flower below. Each color is labeled with a P, S, or T, which stands for Primary, Secondary, and Tertiary. The primary colors are red, yellow, and blue. They are called primary colors because they can't be created by mixing other colors together. When you mix two primary colors together, the result is a secondary color. The secondary colors are orange, green, and purple (also called violet). When you mix a secondary color with a primary color, the result is a tertiary color (also known as an intermediate color). The tertiary colors are yellow-orange, yellow-green, blue-green, blue-purple, red-purple, and red-orange.

Working toward the center of the six large primary and secondary color petals, you'll see three rows of lighter colors, which are called tints. A tint is a color plus white. Moving in from the tints, you'll see three rows of darker colors, which are called shades. A shade is a color plus black. The colors on the top half of the color wheel are considered warm colors (red, yellow, orange), and the colors on the bottom half of the color wheel are considered cool colors (green, blue, purple). Colors opposite one another on the color wheel are called complementary, and colors that are next to each other are called analogous.

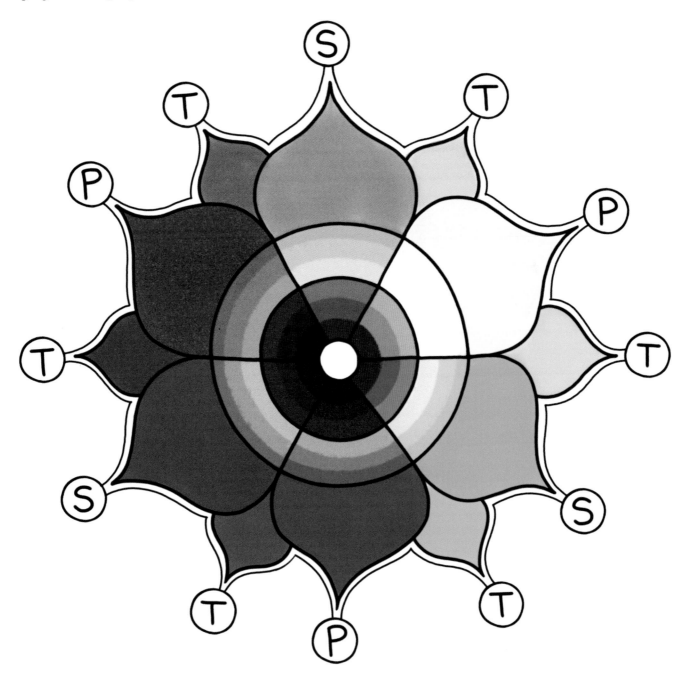

Color Combinations

There are so many ways to combine colors that sometimes it can be overwhelming to think of the possibilities...but it can also be a ton of fun deciding what color scheme you are going to use!

It's important to remember that there is no right or wrong way to color a piece of art, because everyone's tastes are different when it comes to color. Each of us naturally gravitates toward certain colors or color schemes, so over time, you'll learn which colors you tend to use the most (you might already have an idea!). Color theory can help you understand how colors relate to each other, and perhaps open your eyes to new color combos you might not have tried before!

Check out the butterflies below. They are colored in many different ways, using some of the color combinations mentioned in the color wheel section before. Note how each color combo affects the overall appearance and "feel" of the butterfly. As you look at these butterflies, ask yourself which ones you are most attracted to, and why. Which color combinations feel more dynamic to you? Which ones pop out and grab you? Which ones seem to blend harmoniously? Do any combinations seem rather dull to you? By asking yourself these questions, you can gain an understanding of the color schemes you prefer.

Now that you've evaluated some different color schemes, you're ready to start experimenting on paper. When you're getting ready to color a piece of art, test various color combos on scrap paper or in a sketchbook to get a feel for the way the colors work together. When you color, remember to also use the white of the paper as a "color." Not every portion of the art piece has to be filled in with color. Often, leaving a bit of white here and there adds some wonderful variety to the image!

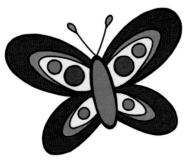
Warm colors

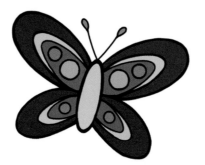
Cool colors

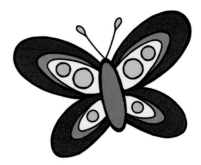
Warm colors with cool accents

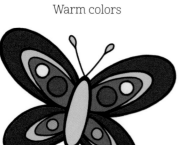
Cool colors with warm accents

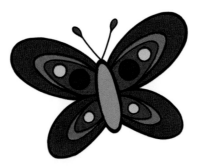
Tints and shades of red

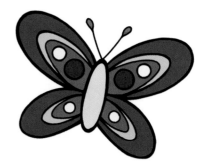
Tints and shades of blue

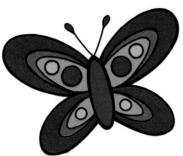
Analogous colors

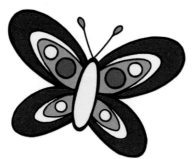
Complementary colors

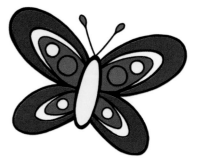
Split complementary colors

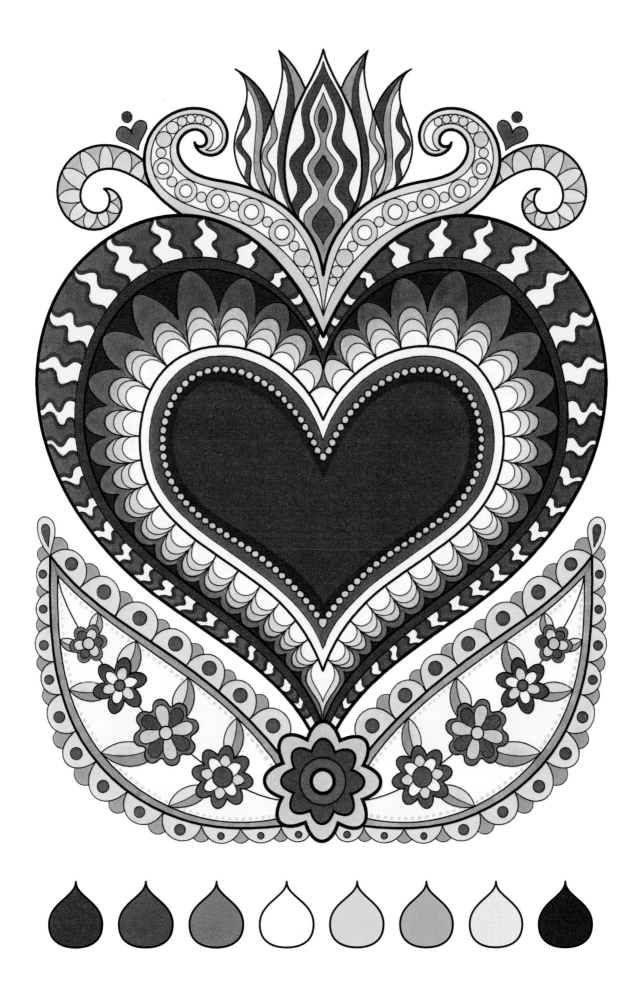

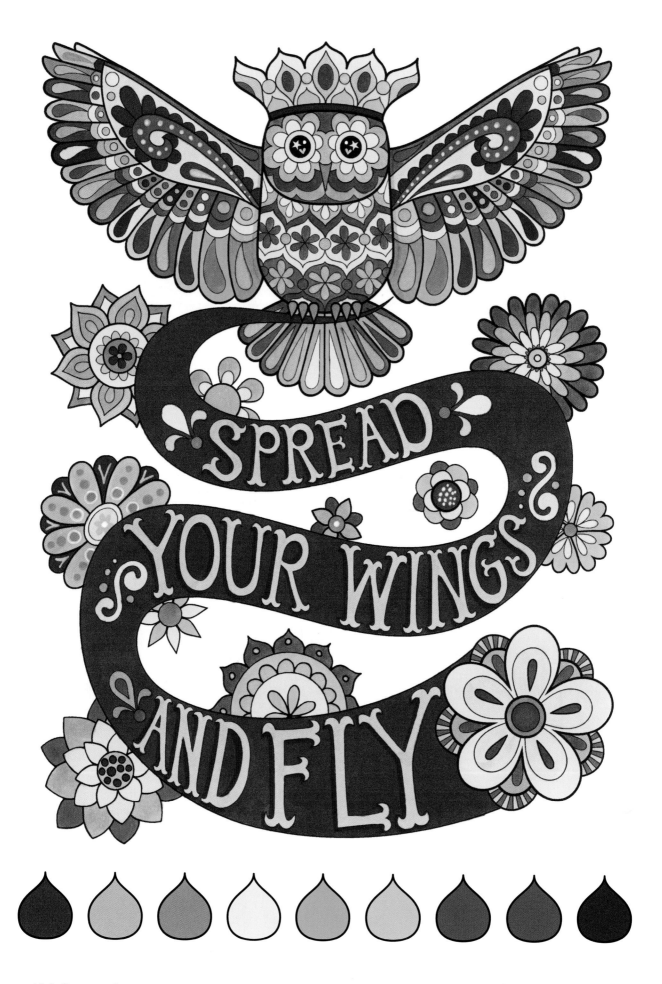

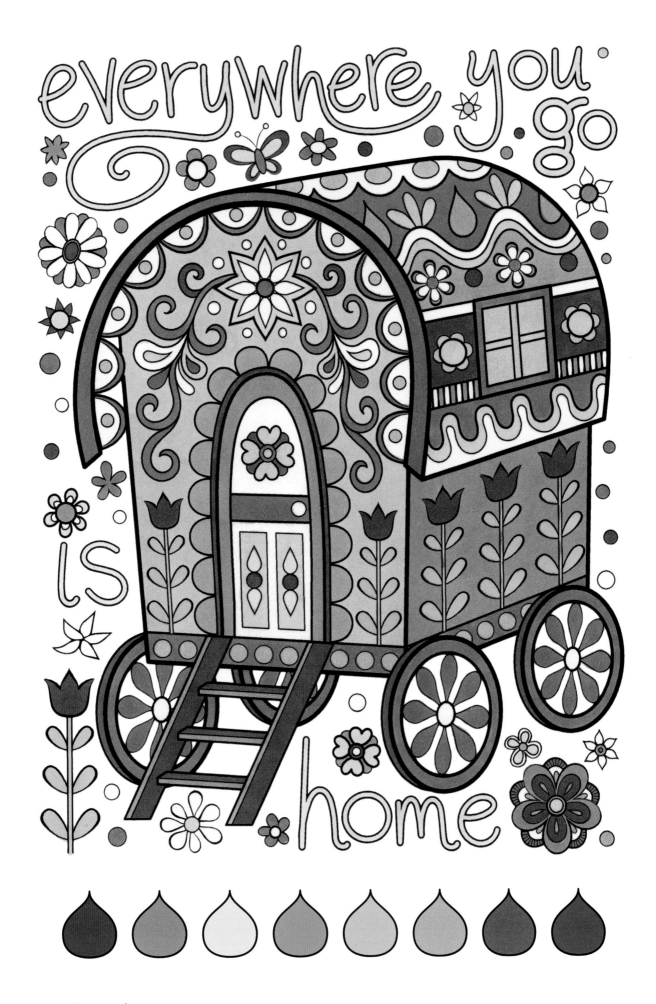

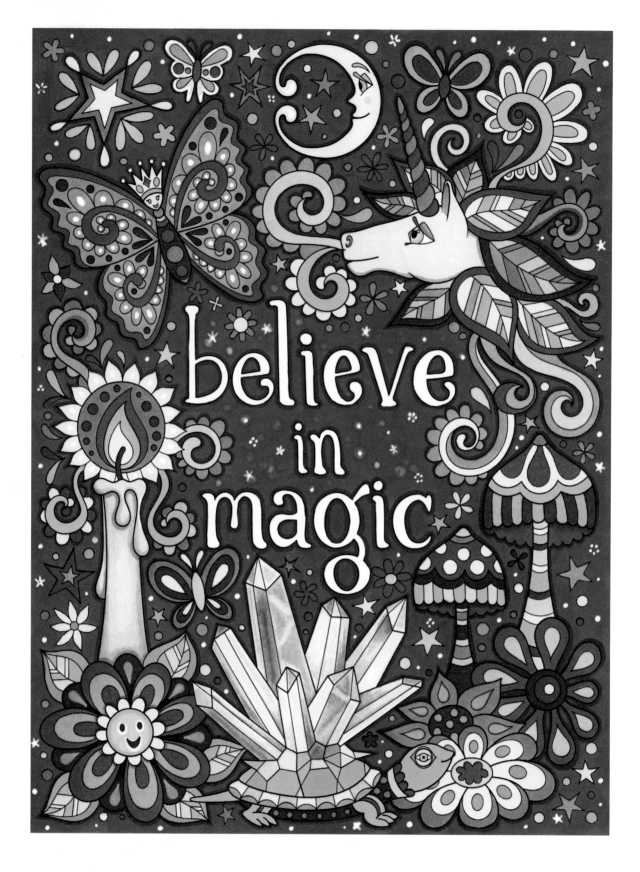

Always remember, it's simply not an adventure worth telling if there aren't any dragons.

—Sarah Ban Breathnach

Let your dreams be bigger than your fears.

—Unknown

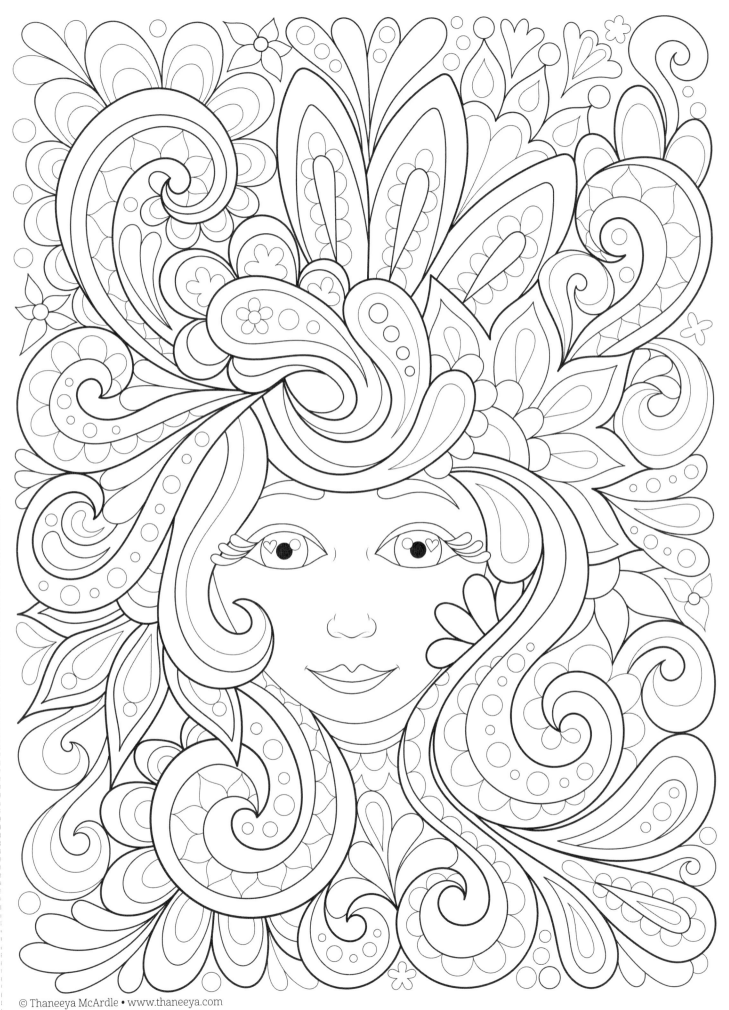

Love her, but leave her wild.

—Atticus

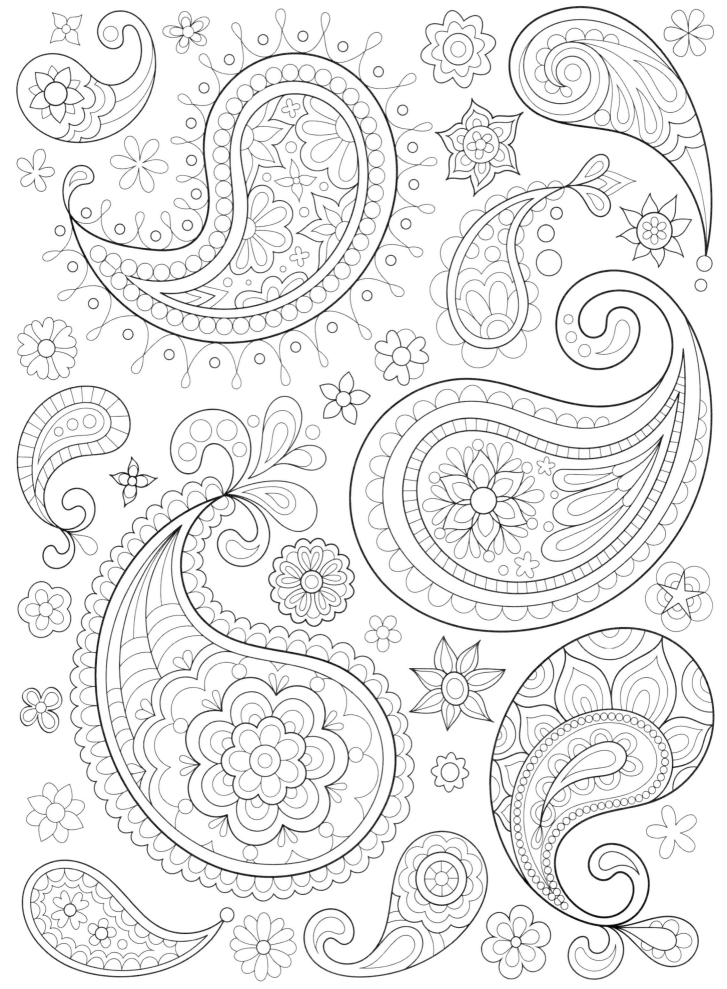

The free soul is rare, but you know
it when you see it—basically because
you feel good, very good, when you
are near or with them.

—Charles Bukowski, *Tales of Ordinary Madness*

I don't have anything to prove to anybody,
which is a lovely place to be.

—Edward Norton

You were once wild here.
Don't let them tame you.

—Isadora Duncan

We need to sing with all the voices
of the mountain
We need to paint with all the colors of the wind

—Colors of the Wind, Pocahontas

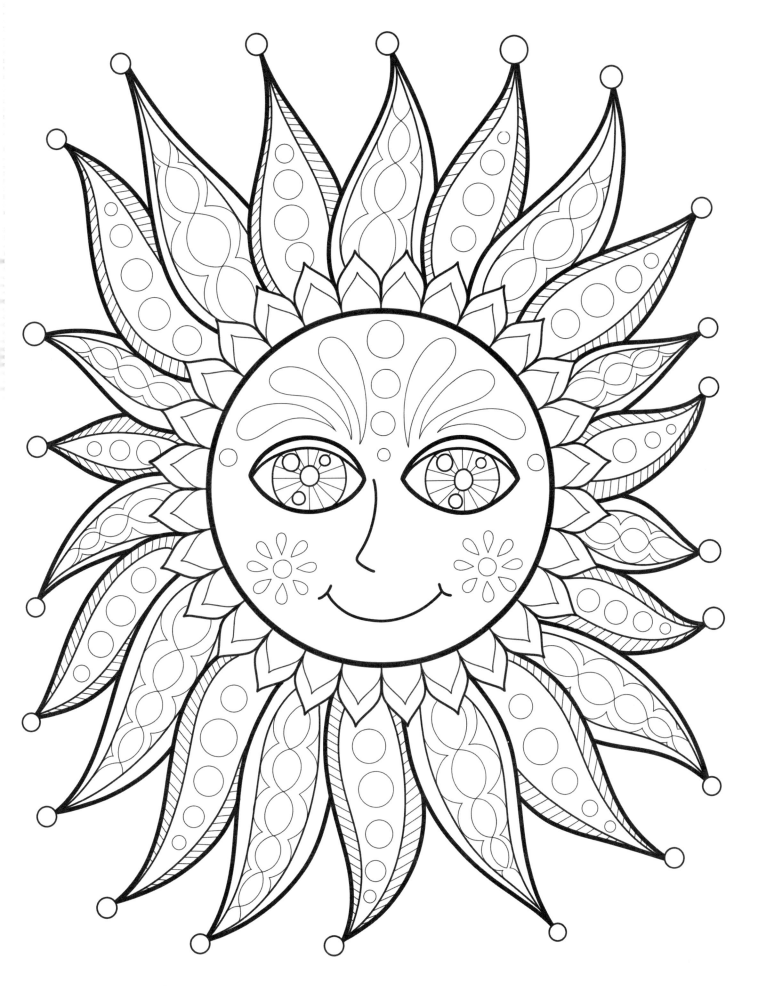

If someone thinks that love and peace is a cliché
that must have been left behind in the sixties,
that's his problem. Love and peace are eternal.

—John Lennon

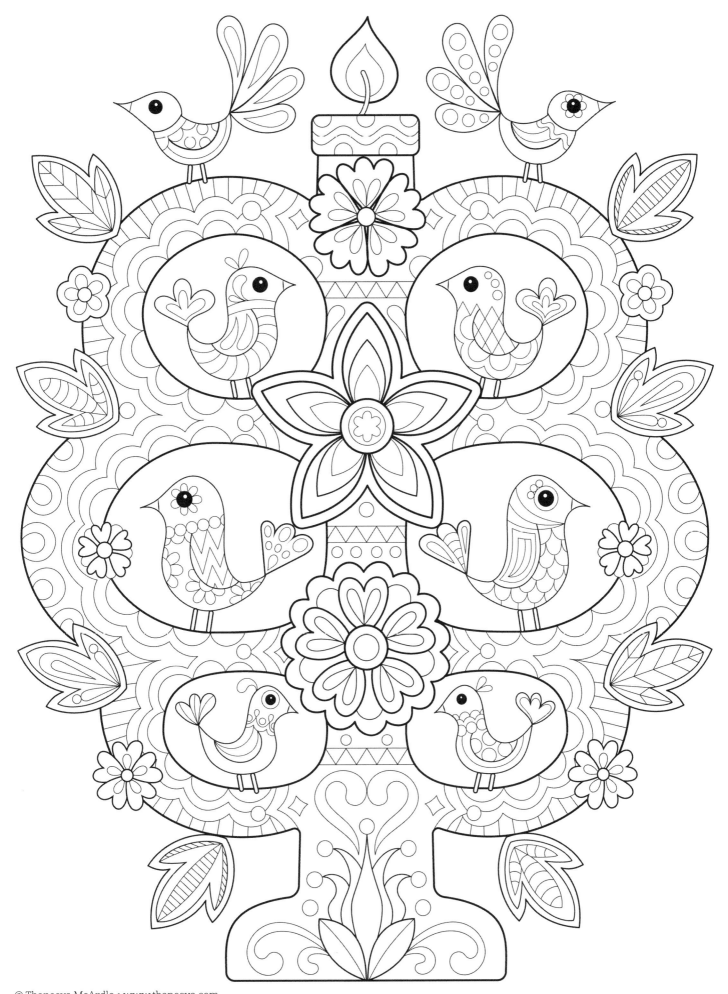

I am a free spirit. Either admire me from the ground or fly with me, but don't ever try to cage me.

—Unknown

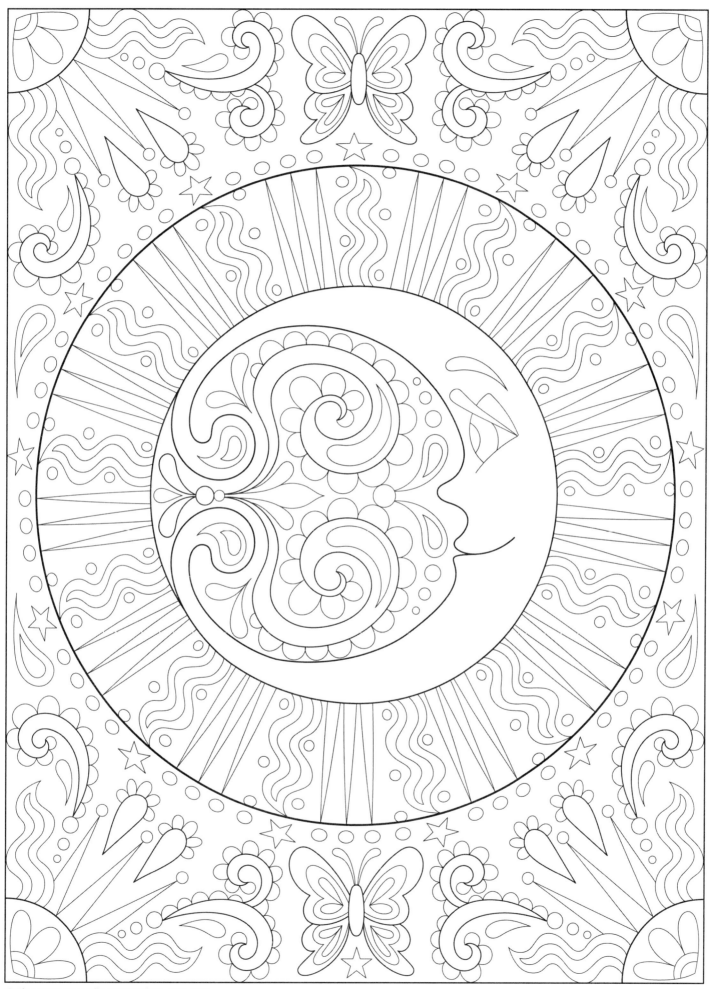

Close your eyes, clear your heart, let it go.

—Unknown

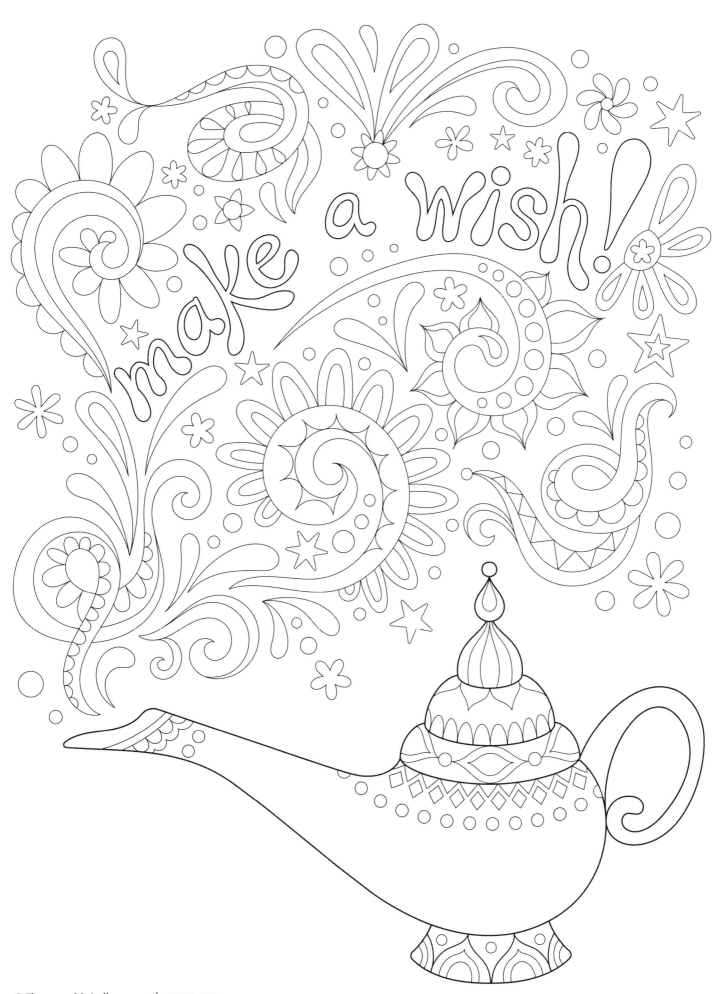

My wish, for you, is that this life
becomes all that you want it to.

—Rascal Flatts, *My Wish*

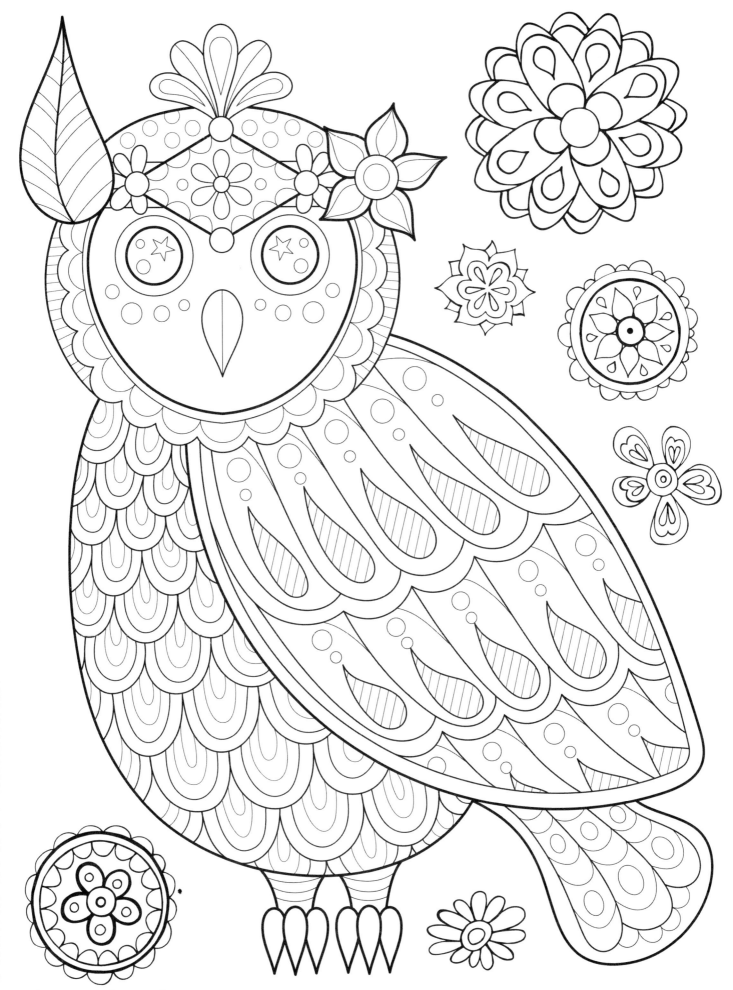

Replace fear of the unknown with curiosity.

—Unknown

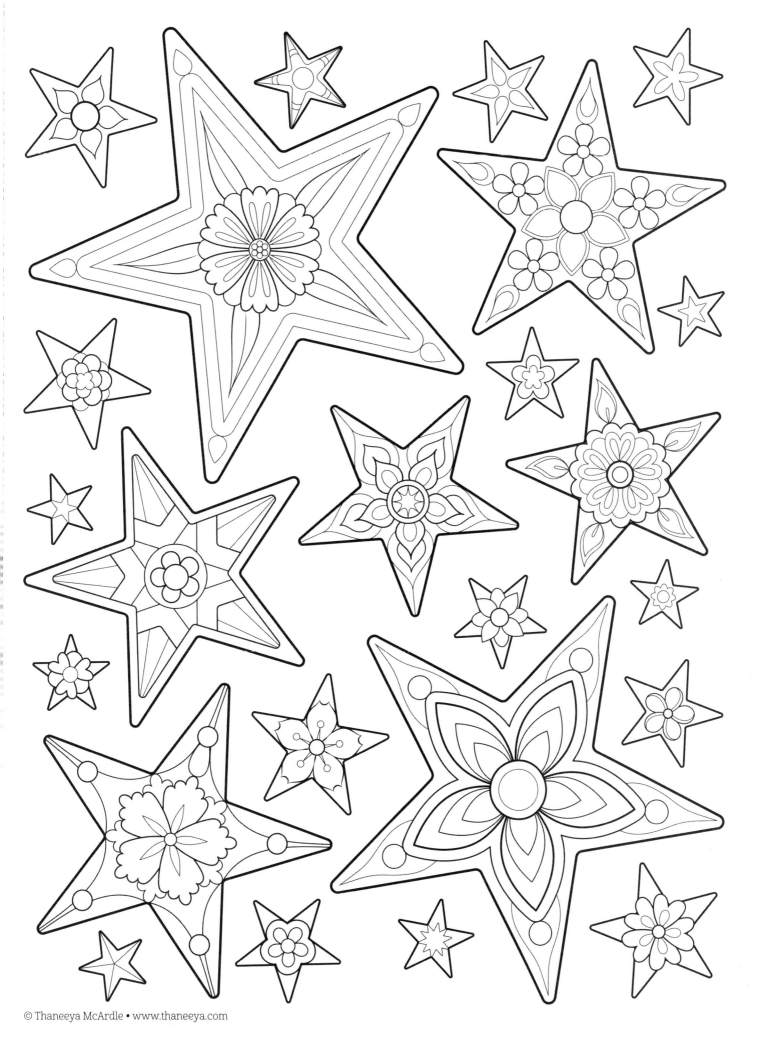

Oh, we could be the stars, falling from the sky
Shining how we want, brighter than the sun

—Colbie Caillat, *Brighter Than the Sun*

Don't bend; don't water it down; don't try
to make it logical; don't edit your own soul
according to the fashion. Rather, follow your
most intense obsessions mercilessly.

—Anne Rice

Great things are done when men
and mountains meet.

—William Blake

May my heart be brave, my mind fierce,
and my spirit free.

—Unknown

always be yourself

People say that you're going the wrong
way when it's simply a way of your own.

—Angelina Jolie

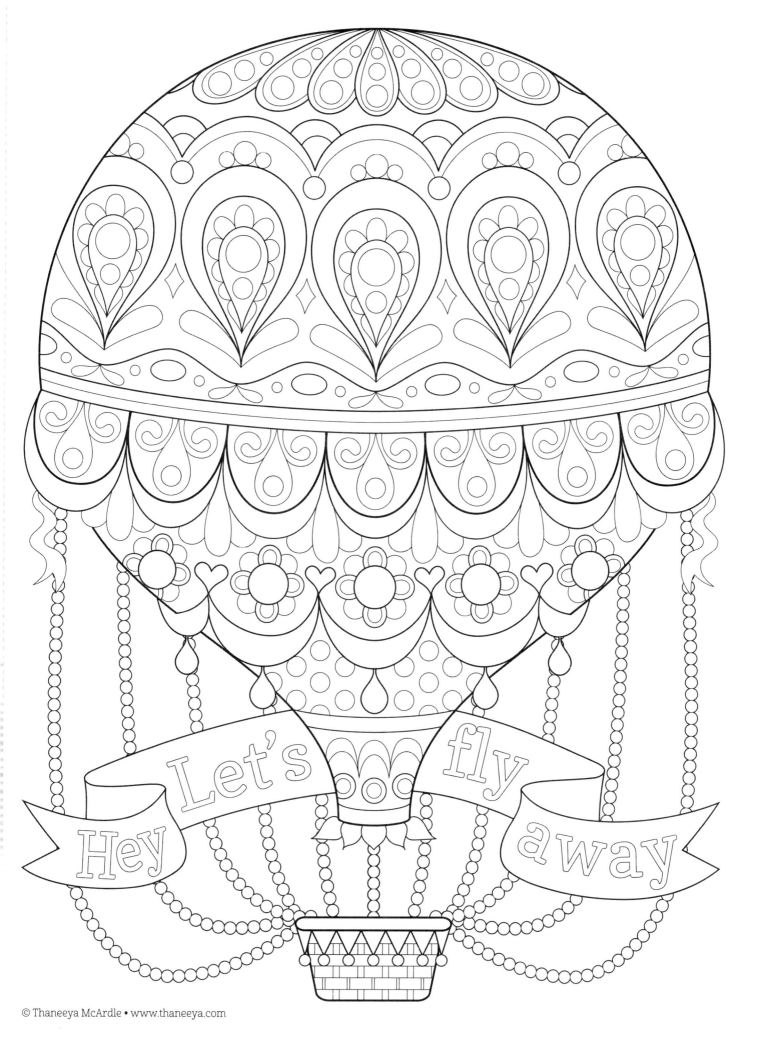

My favorite thing is to go where I've never been.

—Diane Arbus

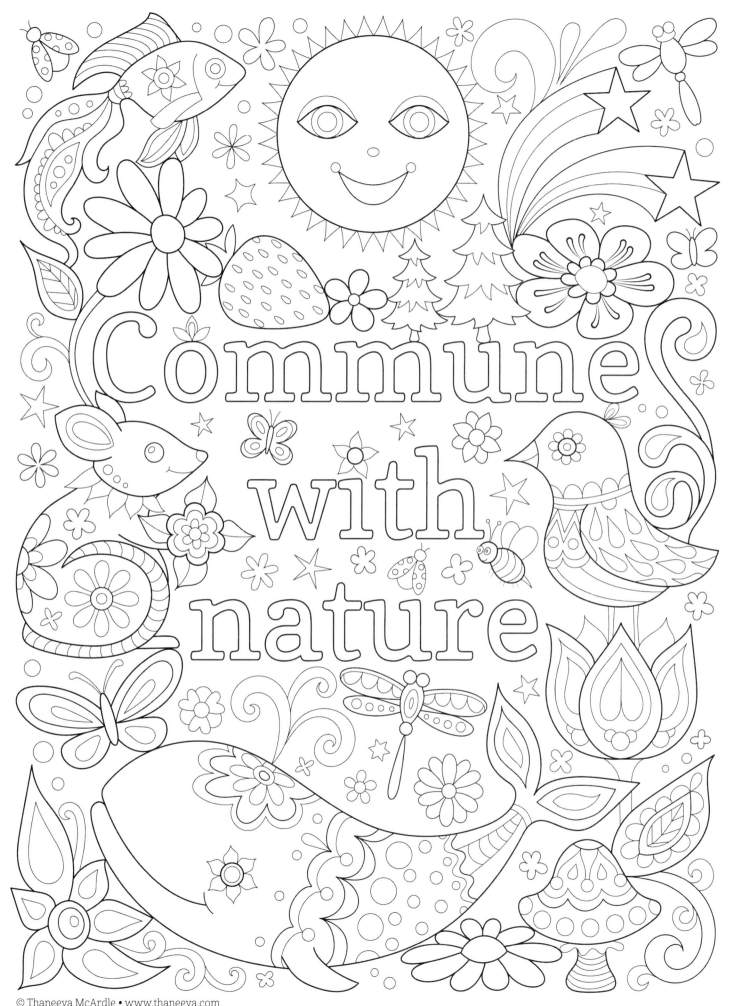

Commune with nature

May your search through Nature
lead you to yourself.

—Unknown

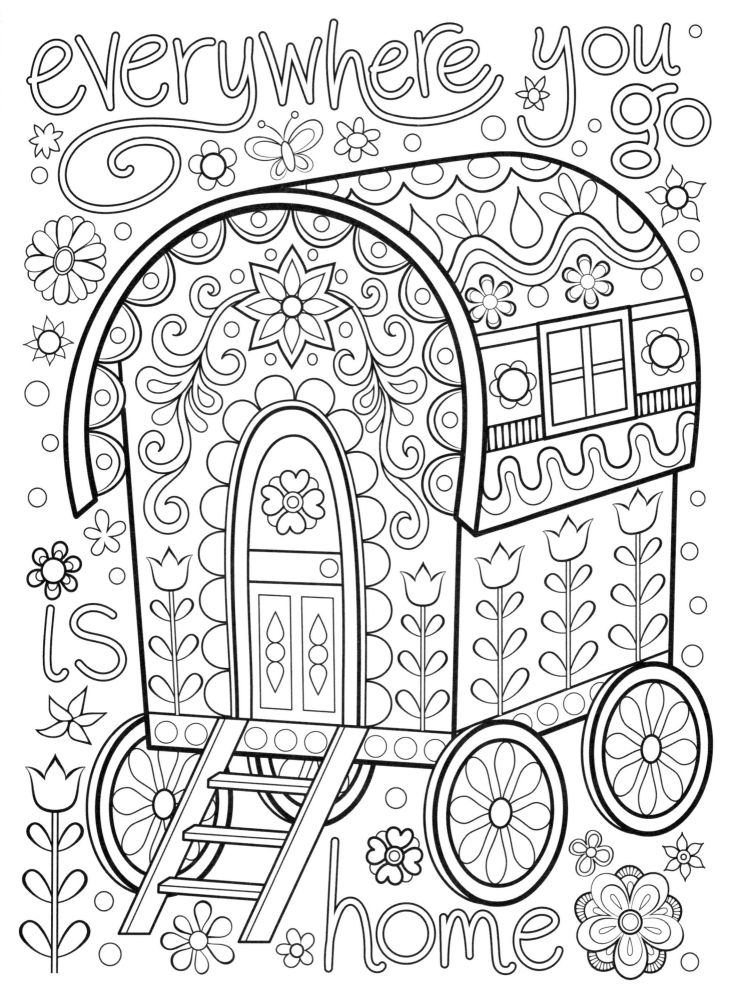

The best moments happen when
they are unplanned.

—Unknown

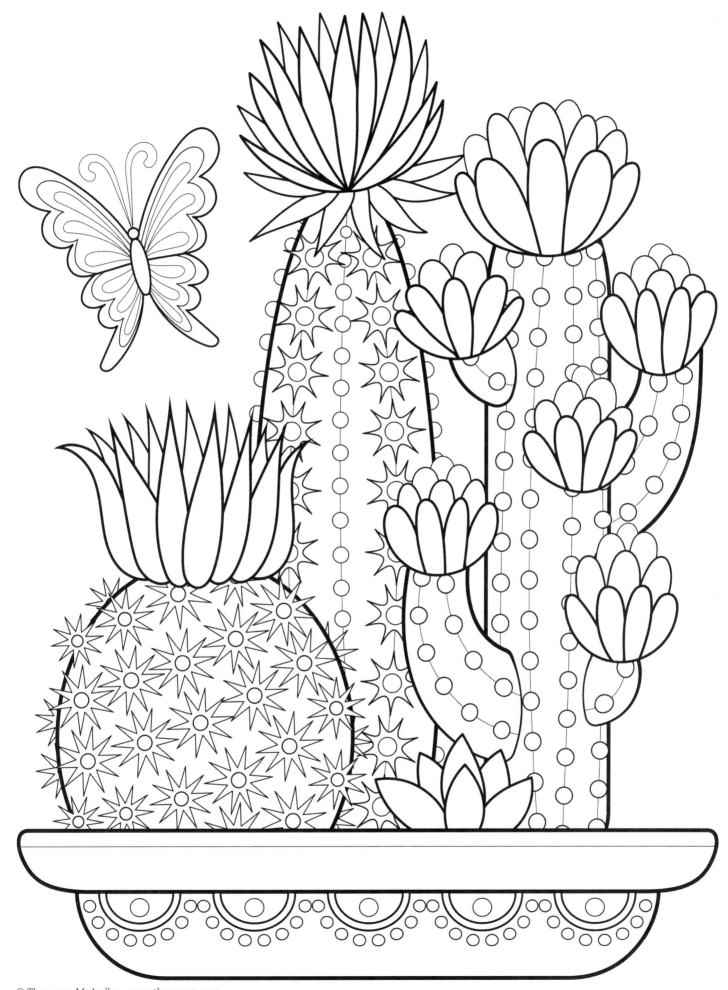

Let your feet take you places, let them remind
you of the beauty your eyes can't see.

—Nikki Rowe

If you are always trying to be normal, you will never know how amazing you can be.

—Maya Angelou

I've been absolutely terrified every moment
of my life—and I've never let it keep me from
doing a single thing I wanted to do.

—Georgia O'Keeffe

Love makes the wildest spirit tame,
and the tamest spirit wild.

—Unknown

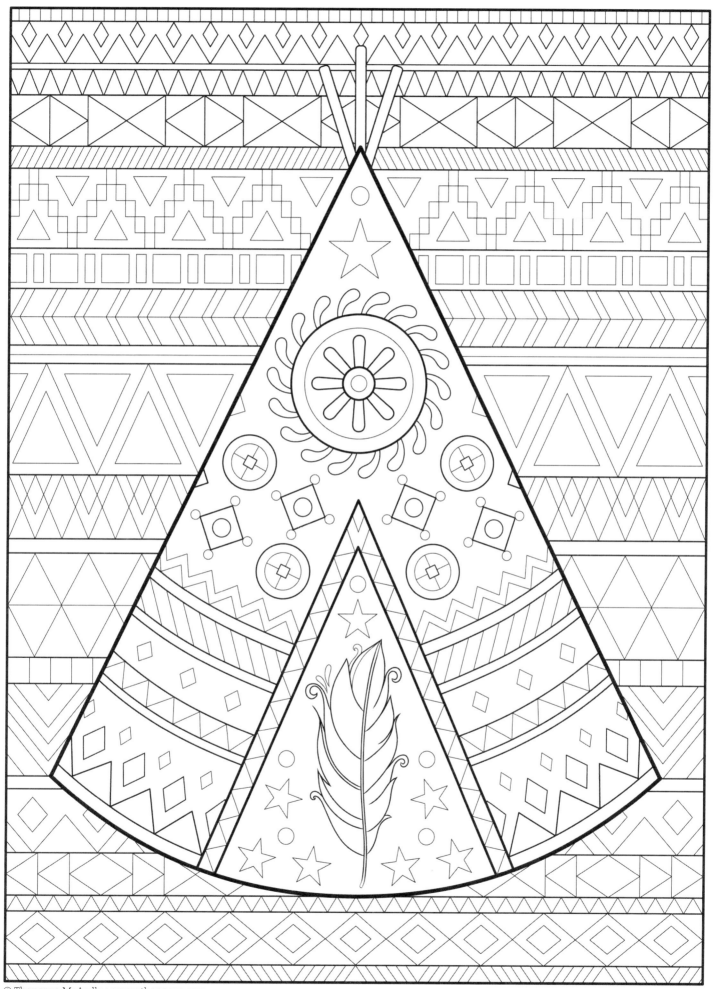

The human spirit needs places where nature
has not been rearranged by the hand of man.

—Unknown

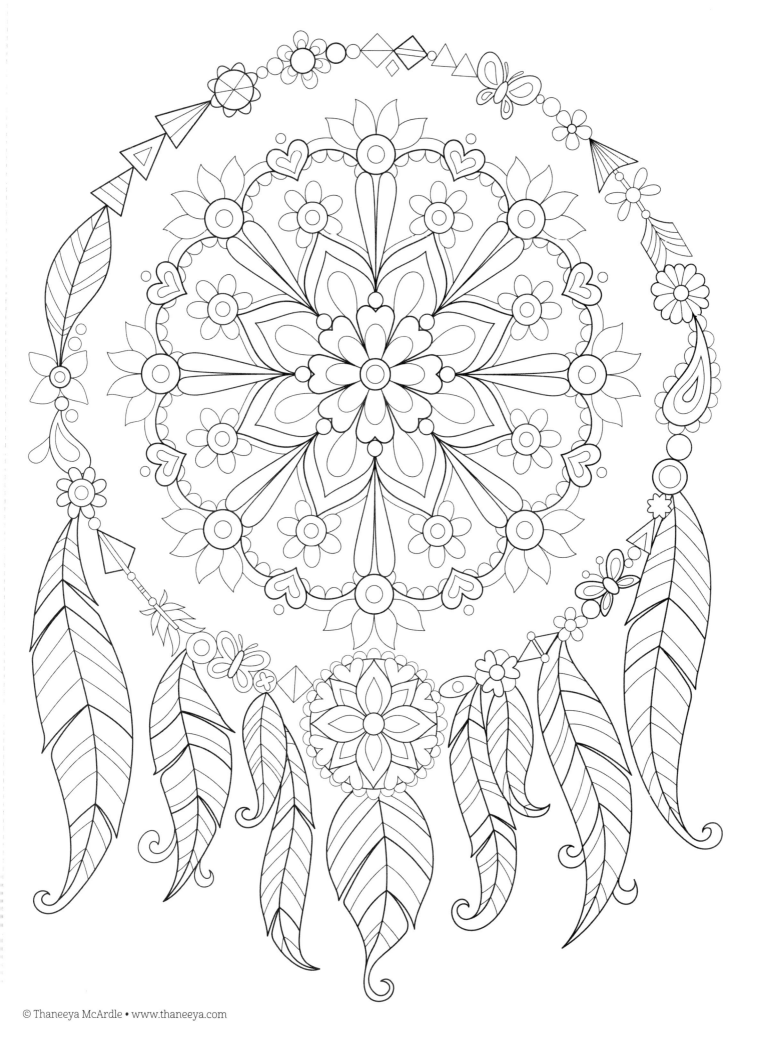

Blessed are the gypsies, the makers of
music, the artists, writers, dreamers of dreams,
wanderers, and vagabonds, children
and misfits, for they teach us to see the
world through beautiful eyes.

—Unknown

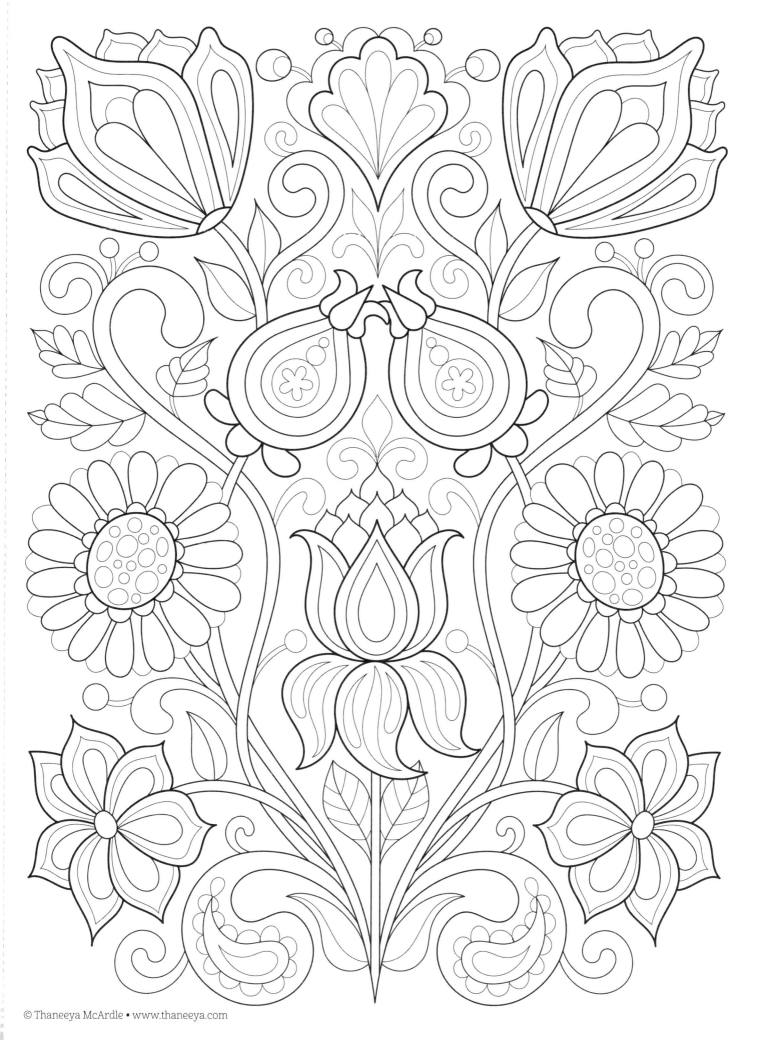

Man's heart away from nature becomes hard.

—Standing Bear

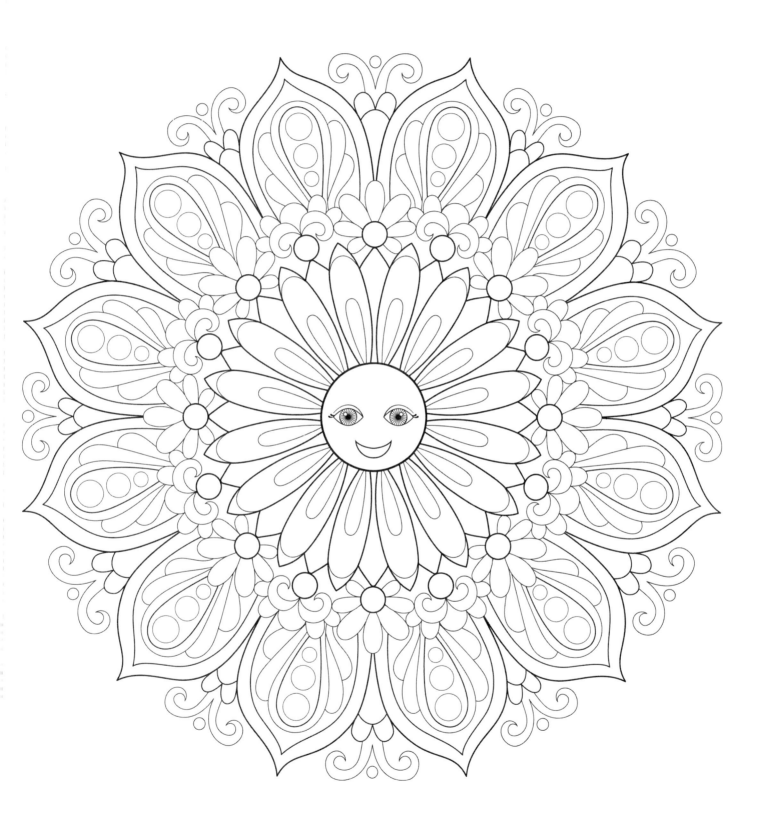

If you want to know where your heart is, look to where your mind goes when it wanders.

—Unknown

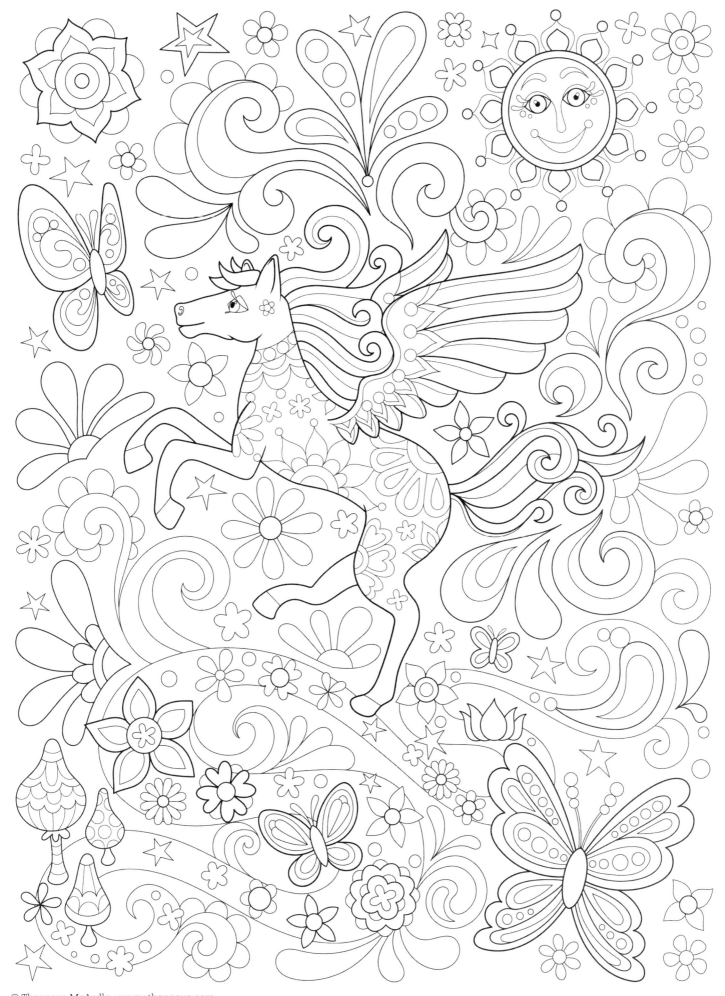

I want to stay as close to the edge as I
can without going over. Out on the edge you
can see all the kinds of things you can't see
from the center.

—Kurt Vonnegut

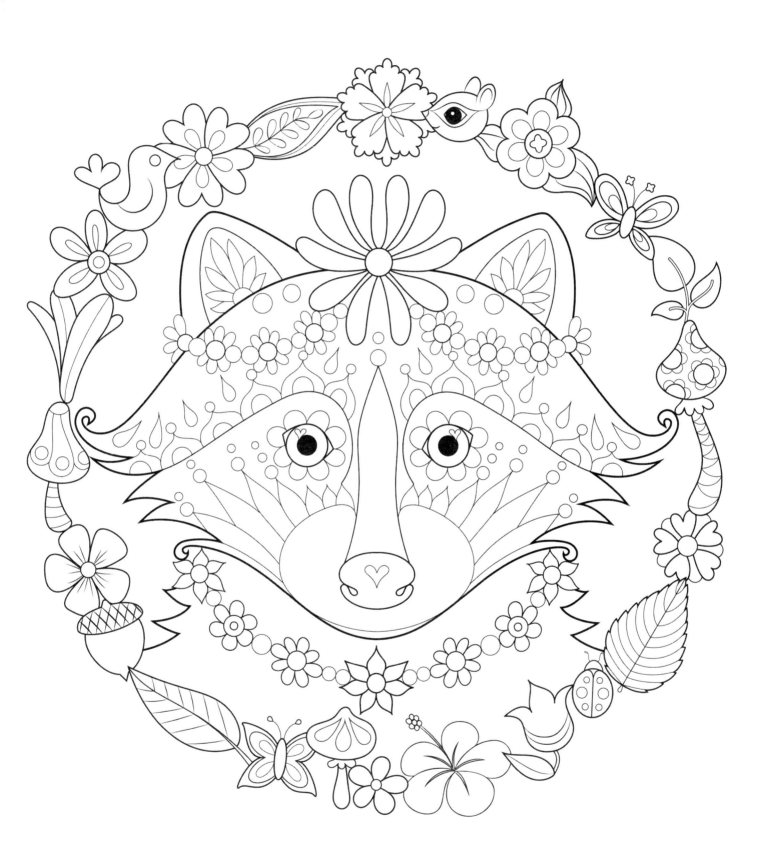

I walked barefoot—the only way to walk
on a muddy road.

—Laurie Gough, *Light on a Moonless Night*

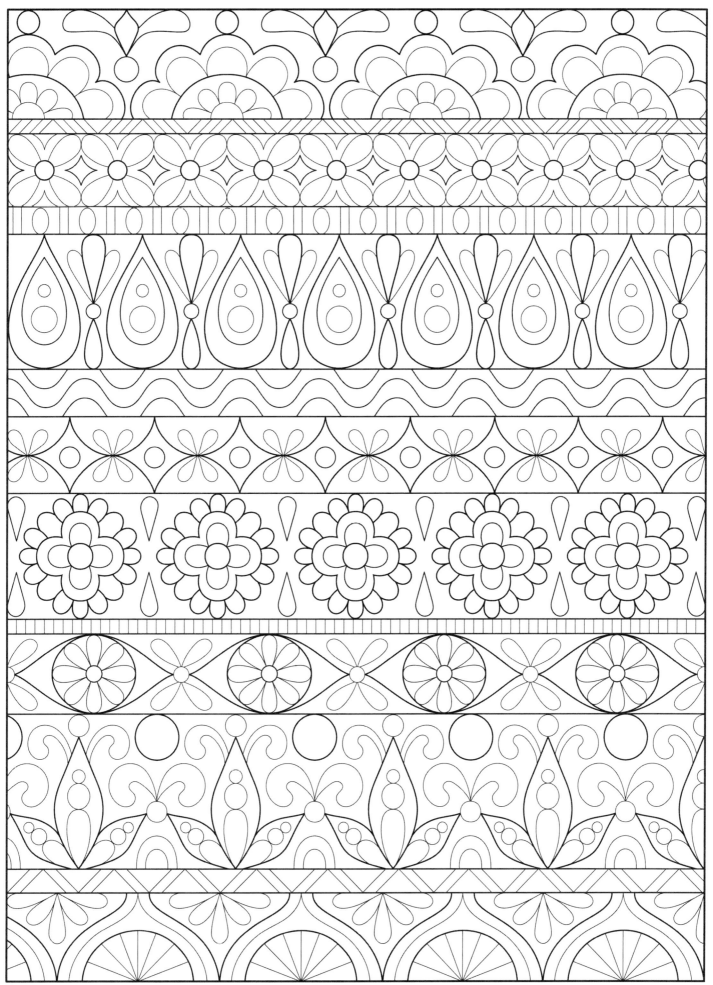

Afoot and light-hearted I take to the open road,
Healthy, free, the world before me,
The long brown path before me leading
wherever I choose.

—Walt Whitman, *Song of the Open Road*

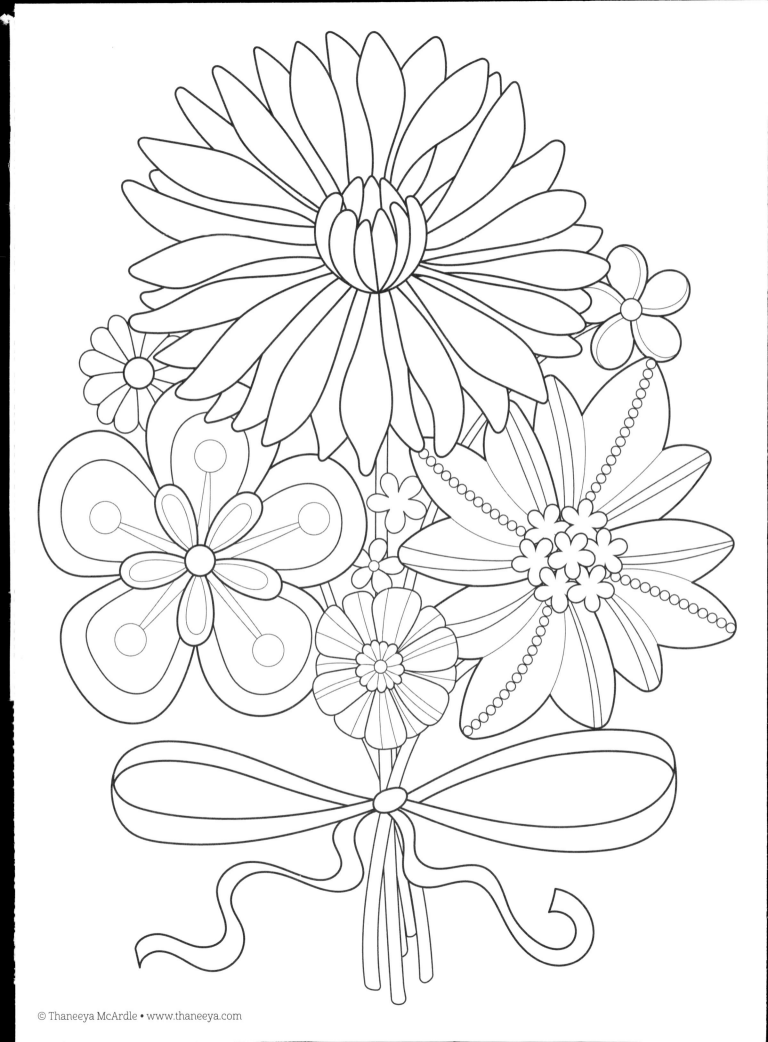

When you know who you are; when your mission is clear and you burn with the inner fire of unbreakable will; no cold can touch your heart; no deluge can dampen your purpose. You know that you are alive.

—Chief Seattle